An Animated Alphabet
BY MARIE ANGEL

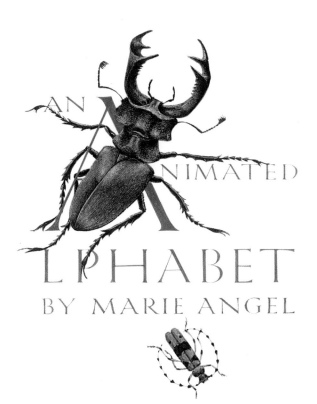

AN ANIMATED

LPHABET

BY MARIE ANGEL

DAVID R. GODINE · PUBLISHER

Boston

ꟼP

A Godine Pocket Paragon
published in 1996 by
DAVID R. GODINE, *Publisher, Inc.*
Box 450
Jaffrey, New Hampshire 03452

Library of Congress Cataloging in Publication Data
Angel, Marie.
An animated alphabet / by Marie Angel
p. cm.
Originally published: Cambridge : Harvard College Library,
Dept. of Print and Graphic Arts, 1971.

ISBN: 1-56792-023-3

1. Angel, Marie—Themes, motives. 2. Alphabets. 3. Bestiaries.
I. Title.
NK3631.A5A4 1996
769'.92-dc20 96-24222
CIP

First printing in color, 1996
Second printing, 1997
This book was printed on acid-free paper
Printed in Hong Kong
by C & C Offset Printing Co., Ltd.

Introduction

FAMILY NEWS, health, and cats—Siamese or Abyssinian—figured prominently over a period of more than twenty years in the warm exchange of letters between Marie Angel, English calligrapher and miniaturist, and Philip Hofer, the founder and first curator of the Department of Printing and Graphic Arts in the Houghton Library. Central to their correspondence, however, was the progress of Marie Angel's work and of their joint publications: her two *Bestiaries* of 1960 and 1964, her *Two Poems by Emily Dickinson* of 1968, and *An Animated Alphabet* of 1970, all reproduced by The Meriden Gravure Company.

Of these, only the *Two Poems* was printed in color because of the prohibitive cost associated with color reproduction. A modest Marie Angel could not help but acknowledge her true feelings upon receiving, in 1972, copies of her newly published *An Animated Alphabet:* "I was rather disappointed when I heard that the *Animated Alphabet* was to be in monochrome but can understand so well how expensive it must be to

produce the drawings in colour." And then she added, good naturedly, "quite frankly, I would just as soon have the careful monochrome that Meriden do so well than poor colour. . . . Meriden seem to get the tonal quality of the drawings so accurately that they 'feel' coloured."

It is thus with particular pleasure that, sixteen years later, the Department of Printing and Graphic Arts and David R. Godine have conspired to bring forth *An Animated Alphabet* in a new edition that does justice both to the subtlety and delicacy of Marie Angel's designs and to the exquisite color of her original drawings.

It would have given great pleasure to the late Philip Hofer to see the wish of his long-time friend and collaborator finally realized.

A N N E A N N I N G E R
Philip Hofer Curator of Printing and Graphic Arts
April 1996

FOREWORD

MISS MARIE ANGEL has by now established herself convincingly as one of the best "animal artists" of our times. She works not only with the skill of a mediaeval manuscript illuminator—usually on small scale—but has also developed her own style of lettering which is classic yet novel, and with a compositional invention that is wholly modern and her own.

Harvard has, therefore, been very fortunate to have been allowed to reproduce and publish her two *Bestiaries* of 1960 and 1964, and, in 1968, her *Two Poems by Emily Dickinson*—this last named in the subtle colors of the original drawings. After several years' experiment, The Meriden Gravure Company succeeded in securing an almost perfect facsimile.

It would be even more difficult and expensive to reproduce all the colors and nuances in the present *Animated Alphabet*. But perhaps the purchasers of this facsimile in monochrome will be pleased that the price is moderate. The originals from which all the above four publications were made are painted and lettered entire-

ly by the artist herself on small pieces of the finest English vellum only very slightly larger than the booklets in which they are published.

Miss Angel is able to make an insect seem large, and if necessary ferocious; she is equally able, even in such small scale, to show a whole, huge elephant, or hippopotamus, or wart hog. Perhaps her supreme genius, however, is to depict *weird* beasts of all kinds, with huge eyes, prehensile feet, and mysterious allure. In this booklet, please examine T for Tarsier! In the writer's opinion, she has never achieved a more entrancing composition—or more fascinating nocturnal creature.

Altogether eighteen subjects in this *Animated Alphabet* are quite new: the cover design, the title, the letters E, I, K, L, M, N, P, Q, R, T, U, V, X, Y, Z, and the colophon. The other eleven letters are from the first and second *Bestiaries.* The *Animated Alphabet* is slightly larger than the two *Bestiaries,* and of a slightly different format.

Someone will surely notice that the robin (R) is smaller than, and different from our own American variety. It is an *English* robin!

<div align="right">

PHILIP HOFER
Cambridge, Massachusetts, 1970

</div>

AN 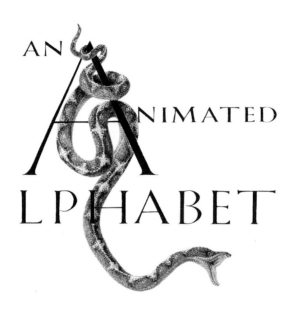NIMATED

LPHABET

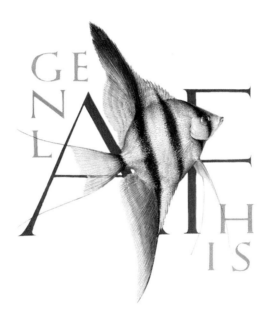

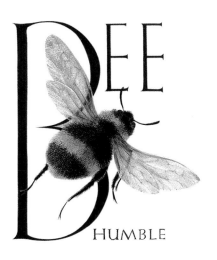

BEE

HUMBLE

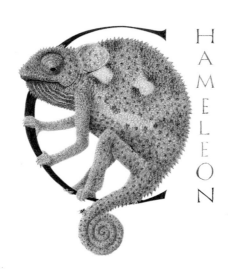

CHAMELEON

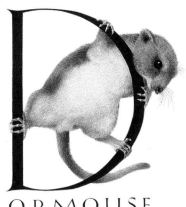

ORMOUSE

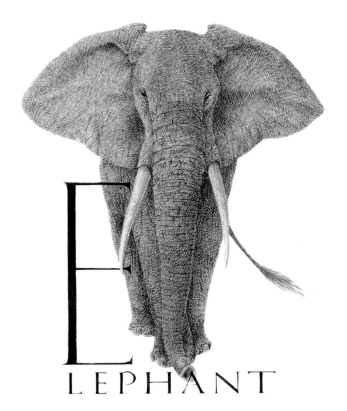

ELEPHANT

QUEEN OF SPAIN

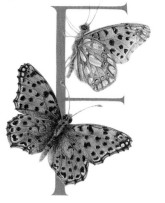

FRITILLARY

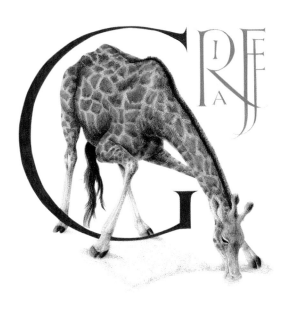

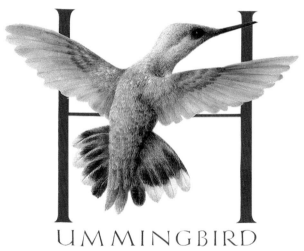

UMMINGBIRD

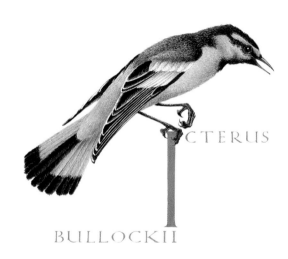

ICTERUS

BULLOCKII

ERBOA

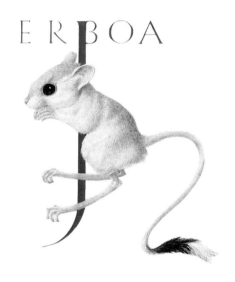

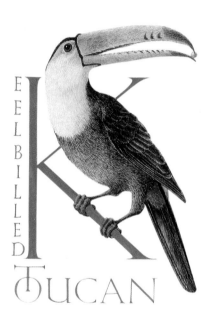

EEL BILLED

TOUCAN

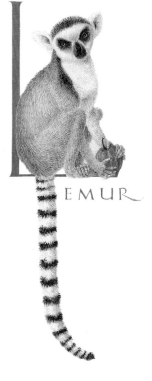

L EMUR

SQUIRREL M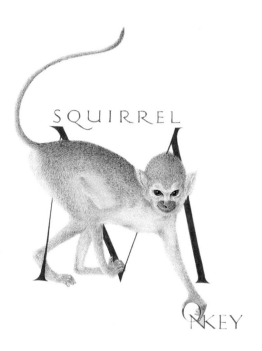ONKEY

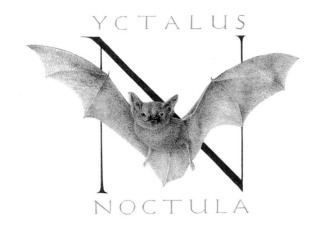

YCTALUS

NOCTULA

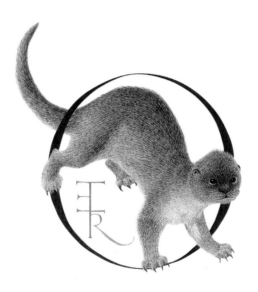

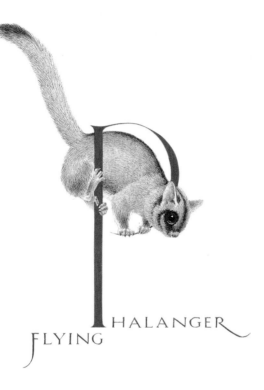

FLYING PHALANGER

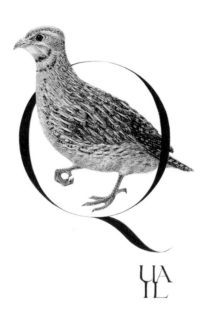

QUAIL

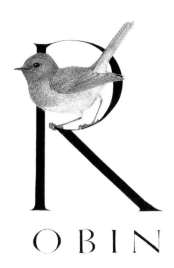

OBIN

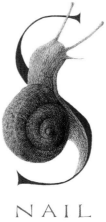

NAIL

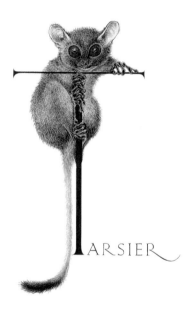

ARSIER

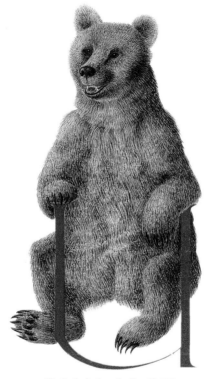

RSUS ARCTOS

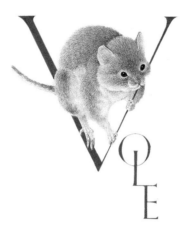

VOLE

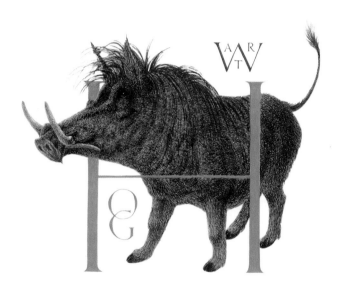

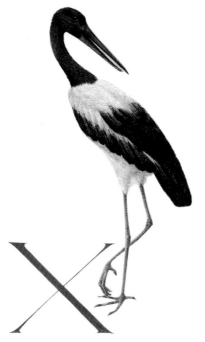

X ENORHYNCHUS
ASIATICUS

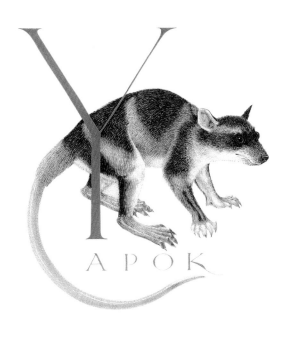

Y
APOK

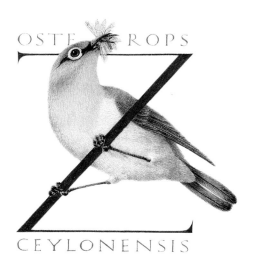

OSTE ROPS

CEYLONENSIS

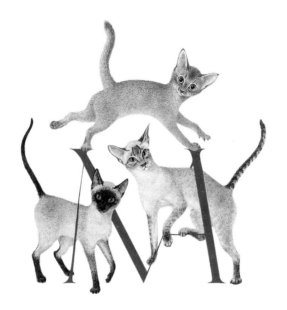

PINXIT
1967 – 1970

ABOUT THE ARTIST

———————

BORN IN 1923, English by birth, and a calligrapher by training, Marie Angel was influenced early on both by her father's passion for gardening and his knowledge of plants and animals, and by her mother's encouragement to draw and paint. The rich variety of shape and purity of color that characterize her work largely derive from an early affection for her childhood garden and household pets. After graduation from the Croydon School of Art and Crafts, Marie Angel attended the Royal College of Art in London, where she studied under Dorothy Mahoney and Irene Wellington and where she realized that her talents as a miniaturist and an illuminator were at least equal to her considerable gifts as a calligrapher. On leaving college, she began to receive commissions for drawings and illuminations from American collectors. Her work is now in the permanent collections of the Hunt Botanical Library, Casa del Libro, the Victoria and Albert Museum, Bodleian Library, and the Department of Printing and Graphic Arts of the Houghton Library, Harvard University. She is the author of two books on calligraphy, *The Art of Calligraphy* and *Painting for Calligraphers,* as well as the illustrator of several children's books.

DEO GRATIAS: MCMXCVI